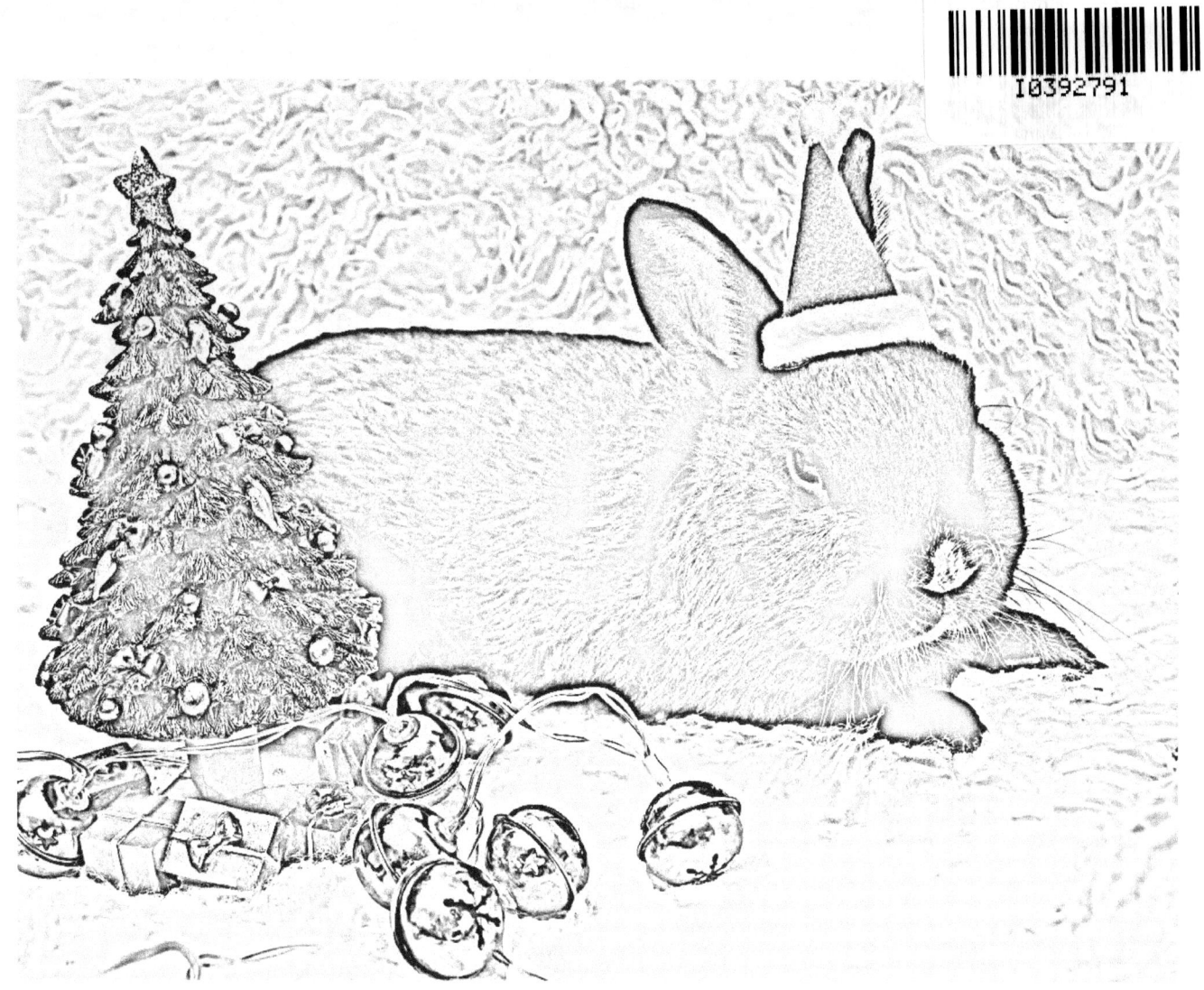

"Does this job pay in carrots?"

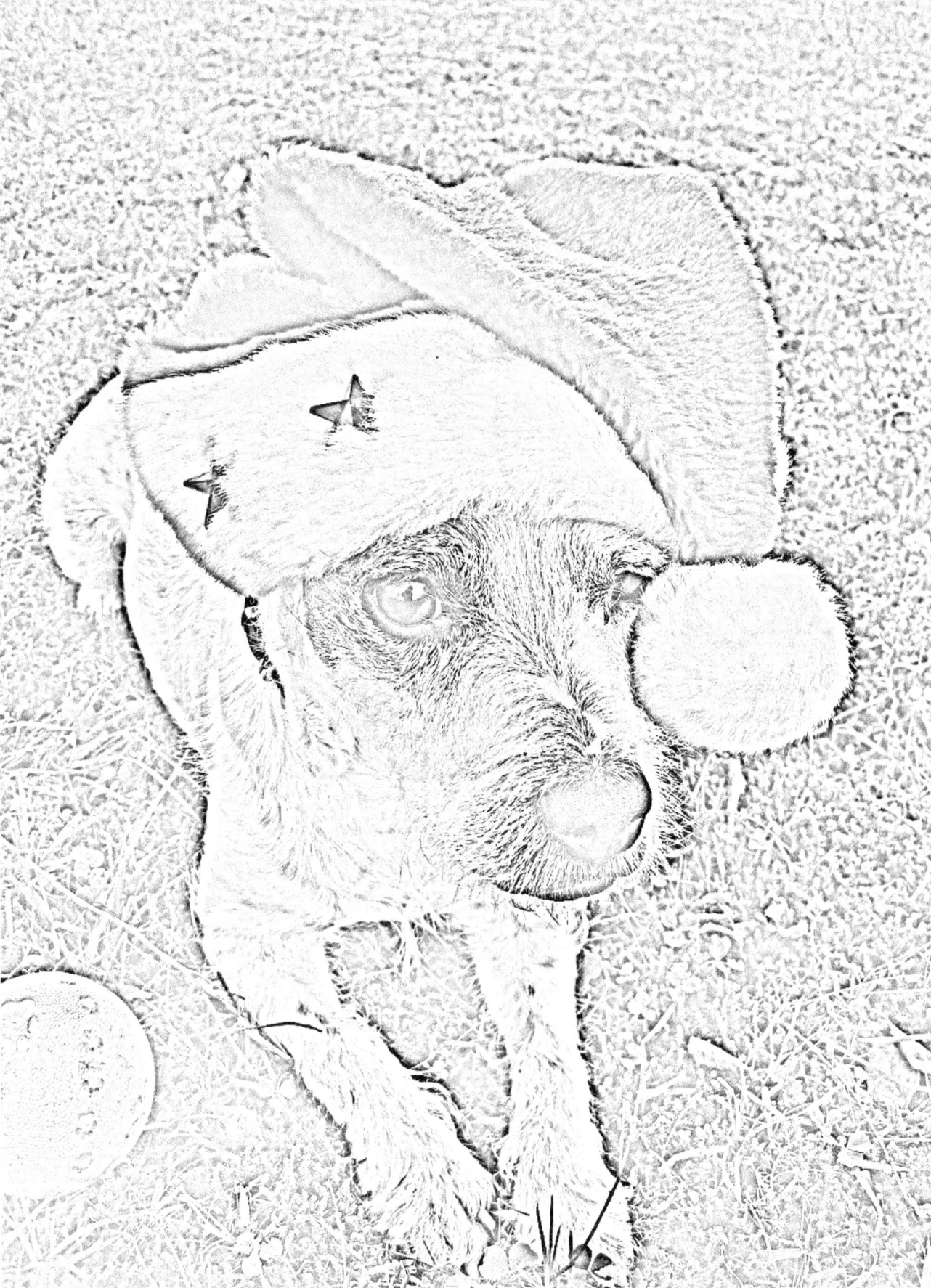

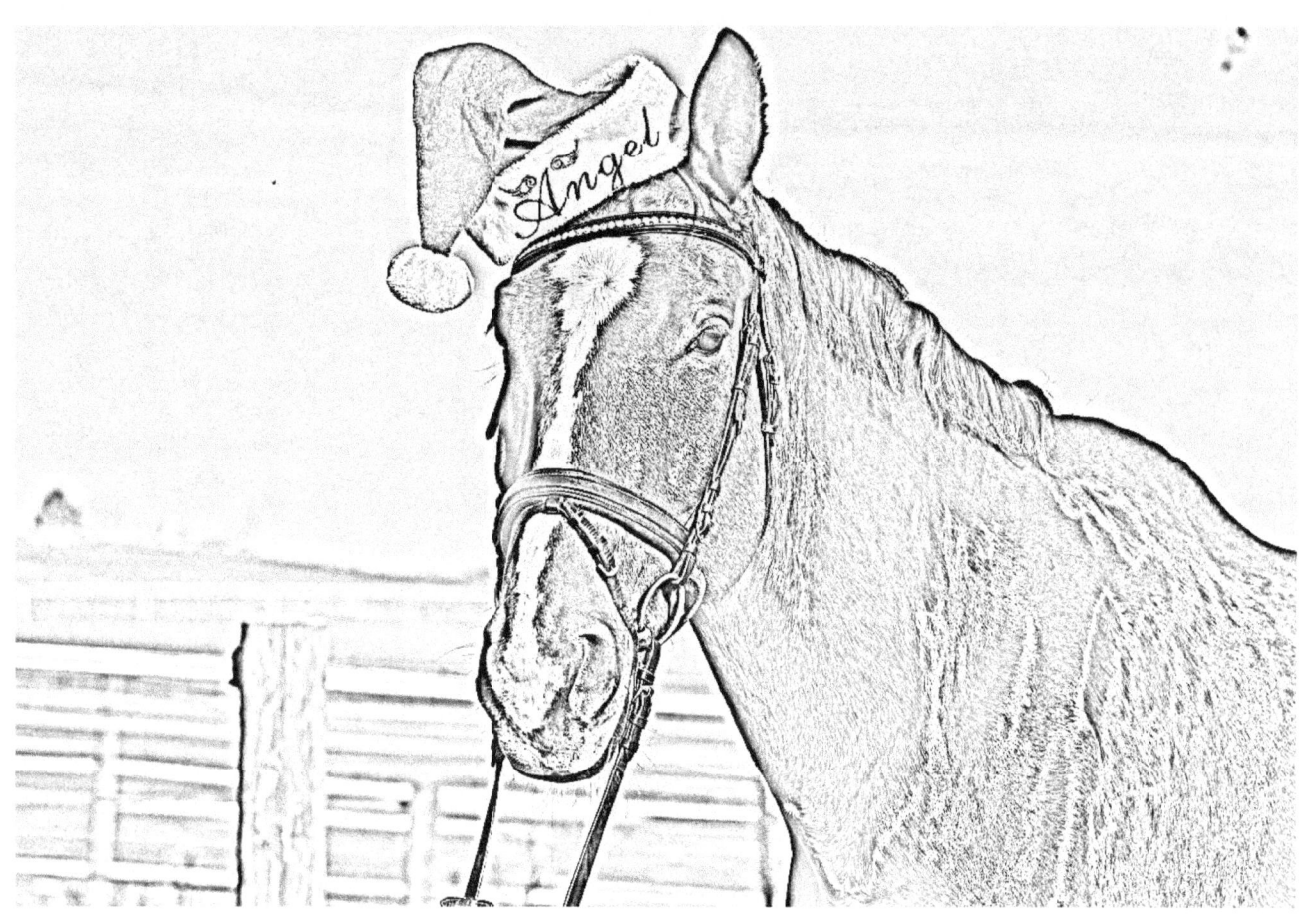

"No horsing around, Do you think Santa will like my hat?"

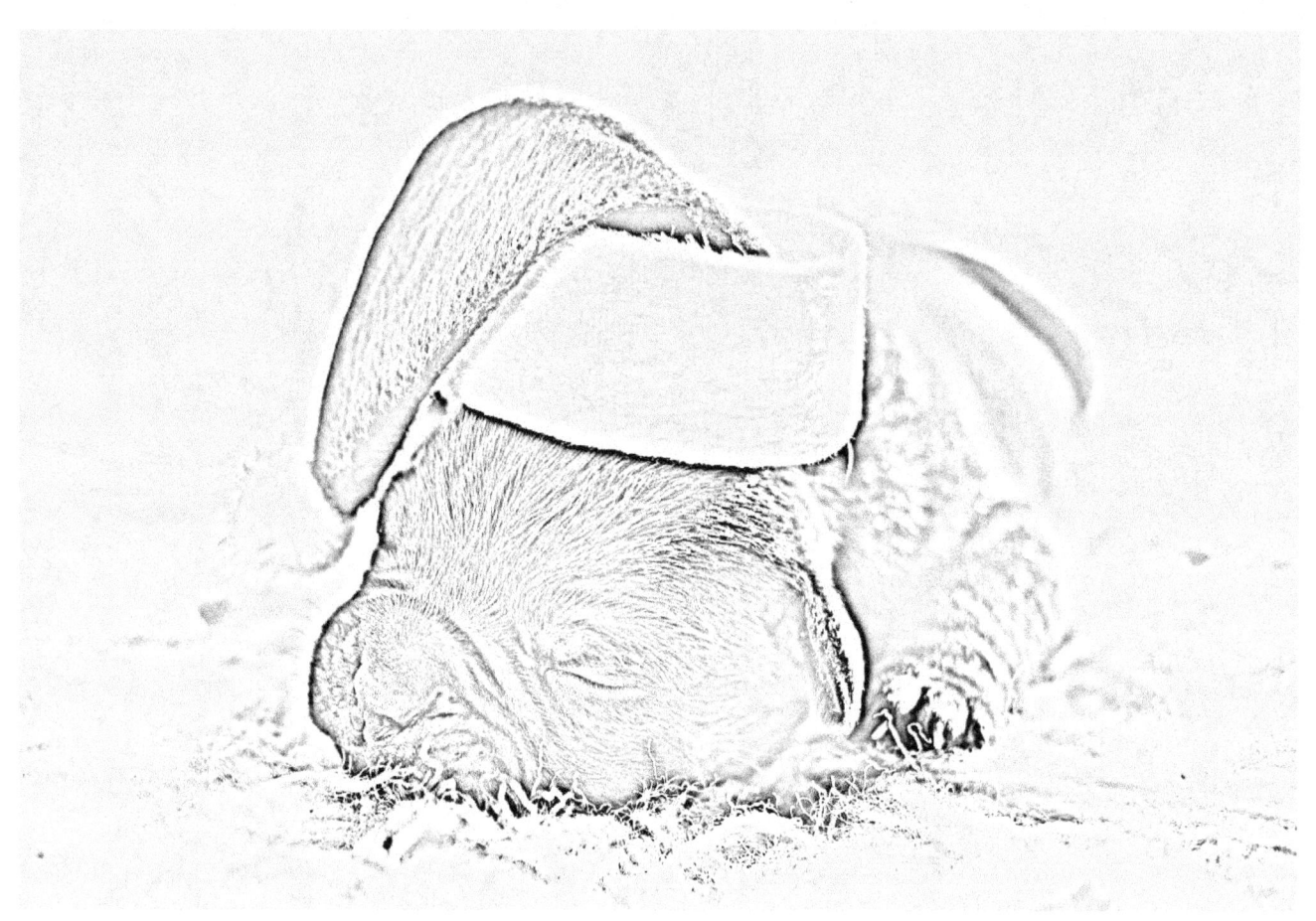

"Santa, I'm dreaming of a new chew toy."

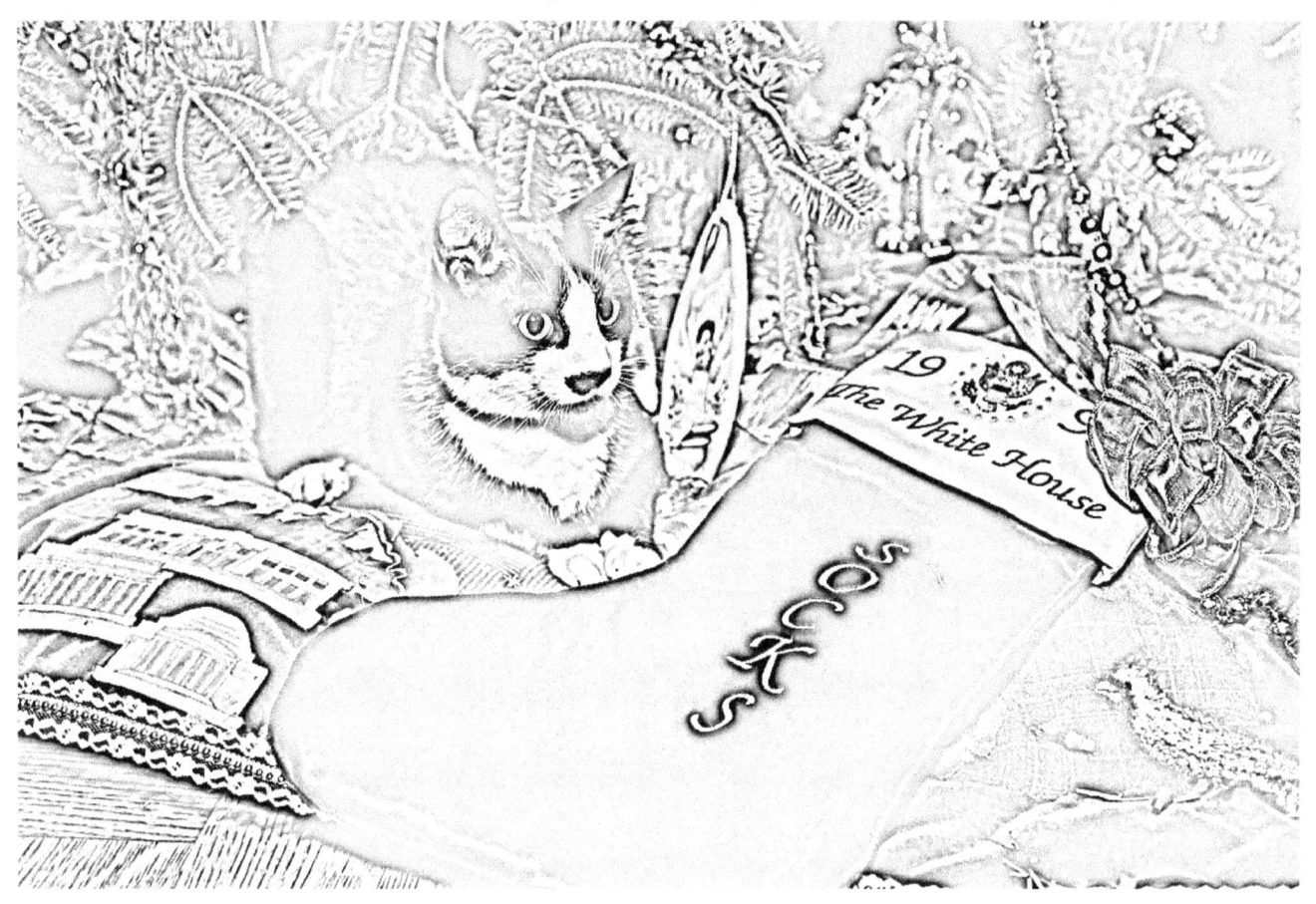

"I refuse to climb into the stocking."

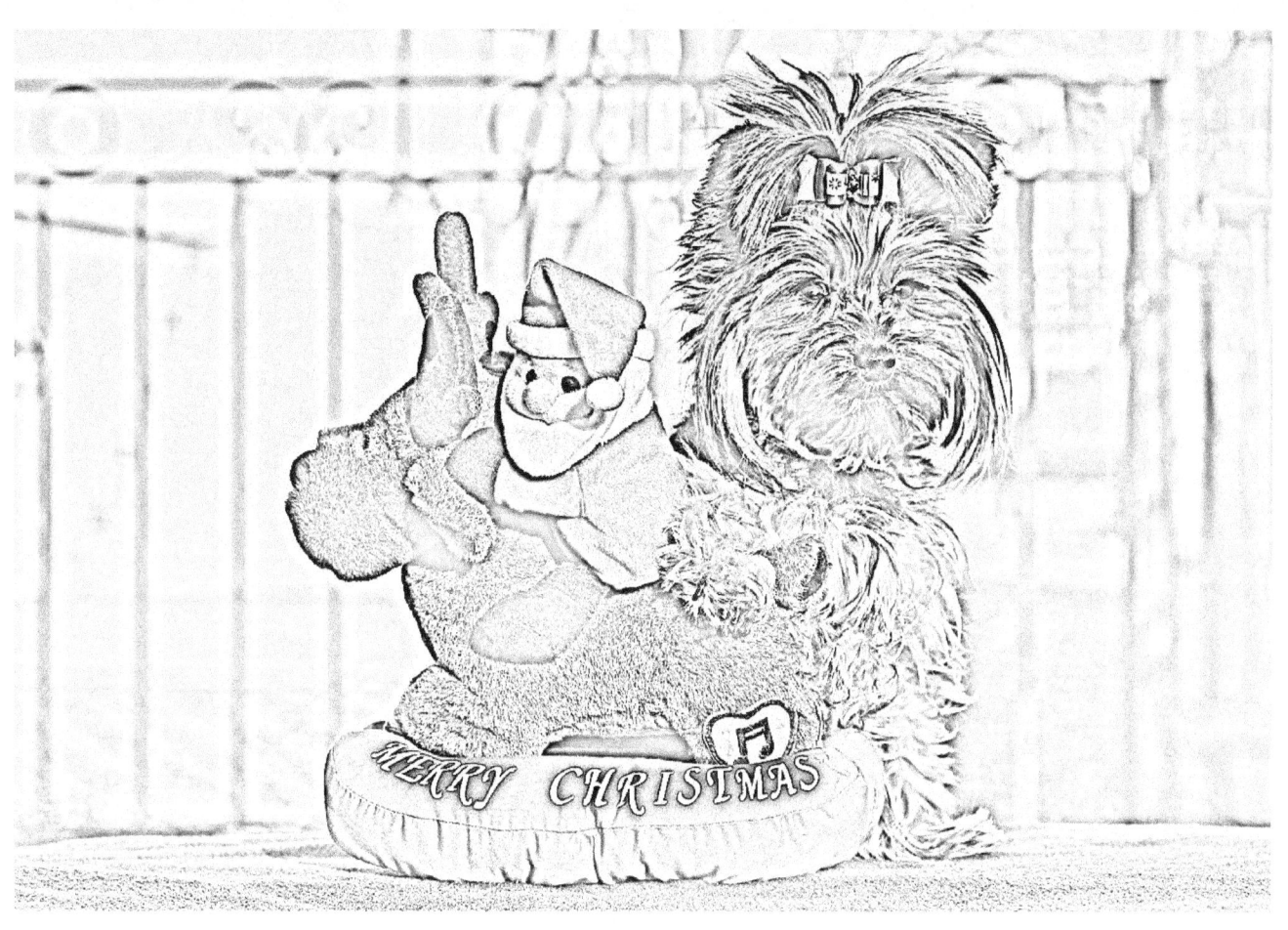

"I look so cute sitting beside Santa."

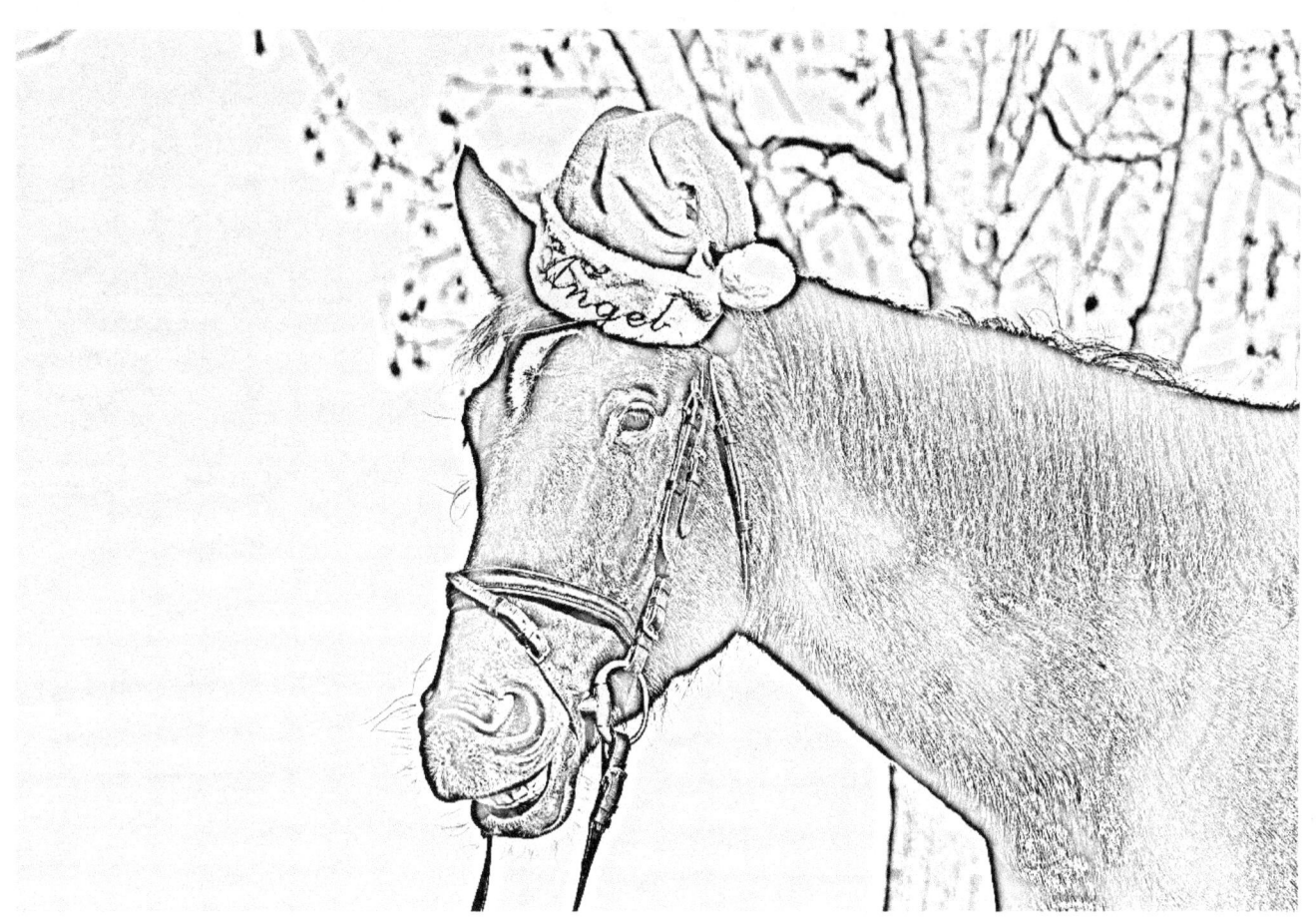

"Have a Meigh~~rry Christmas"

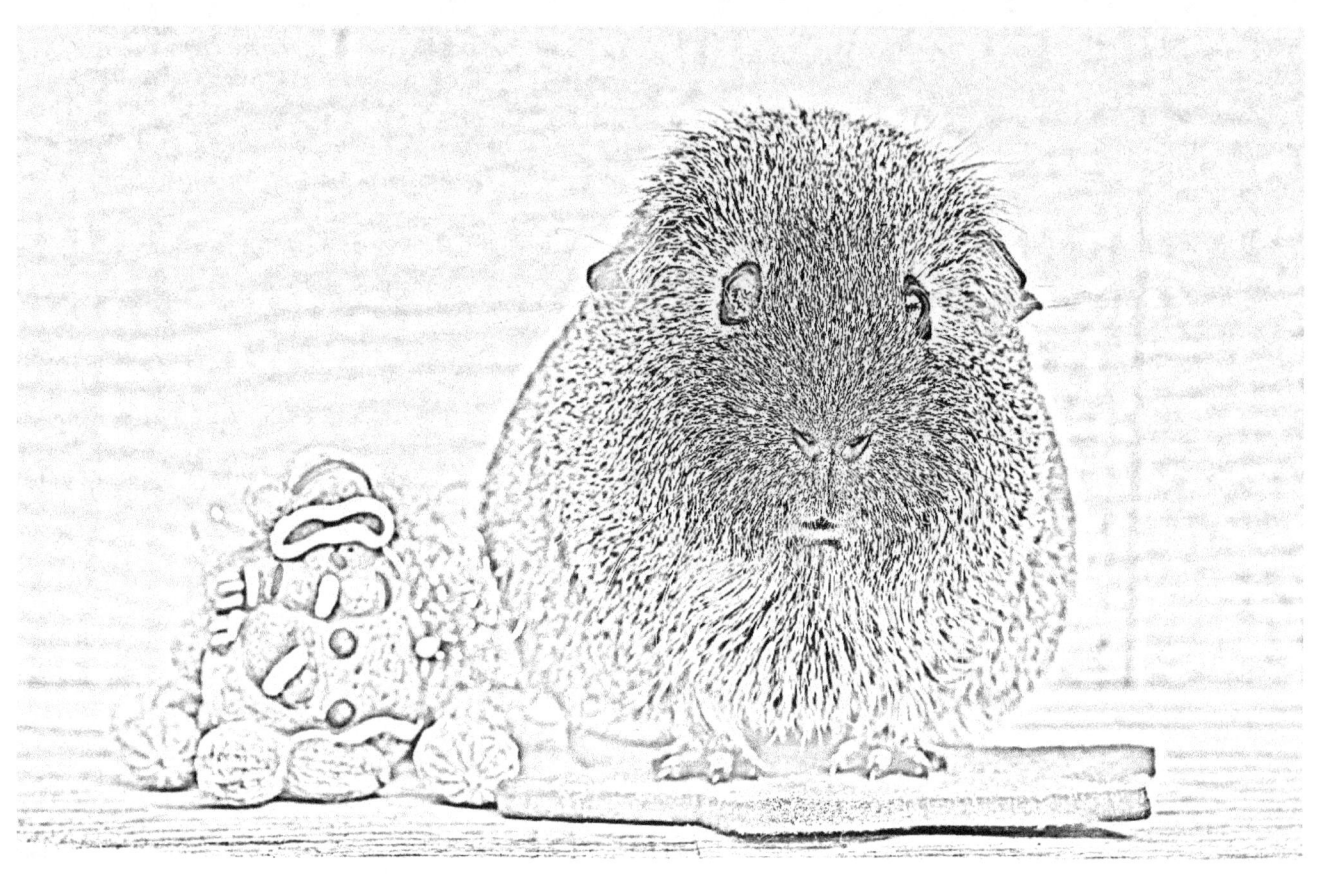

"Santa, I promise I've been a good little Guinea Pig."

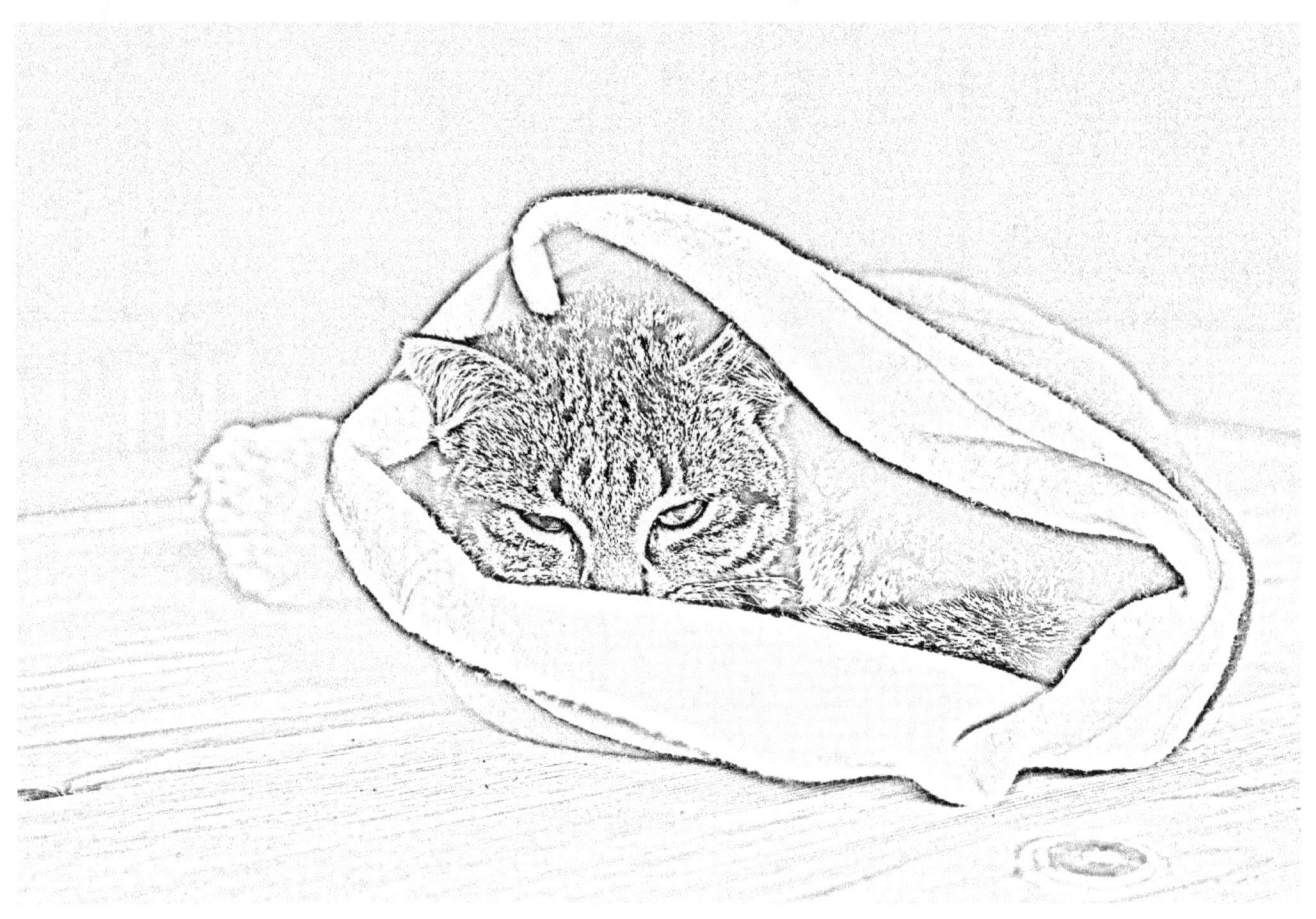

"Santa's in for a surprise when he picks up his hat."

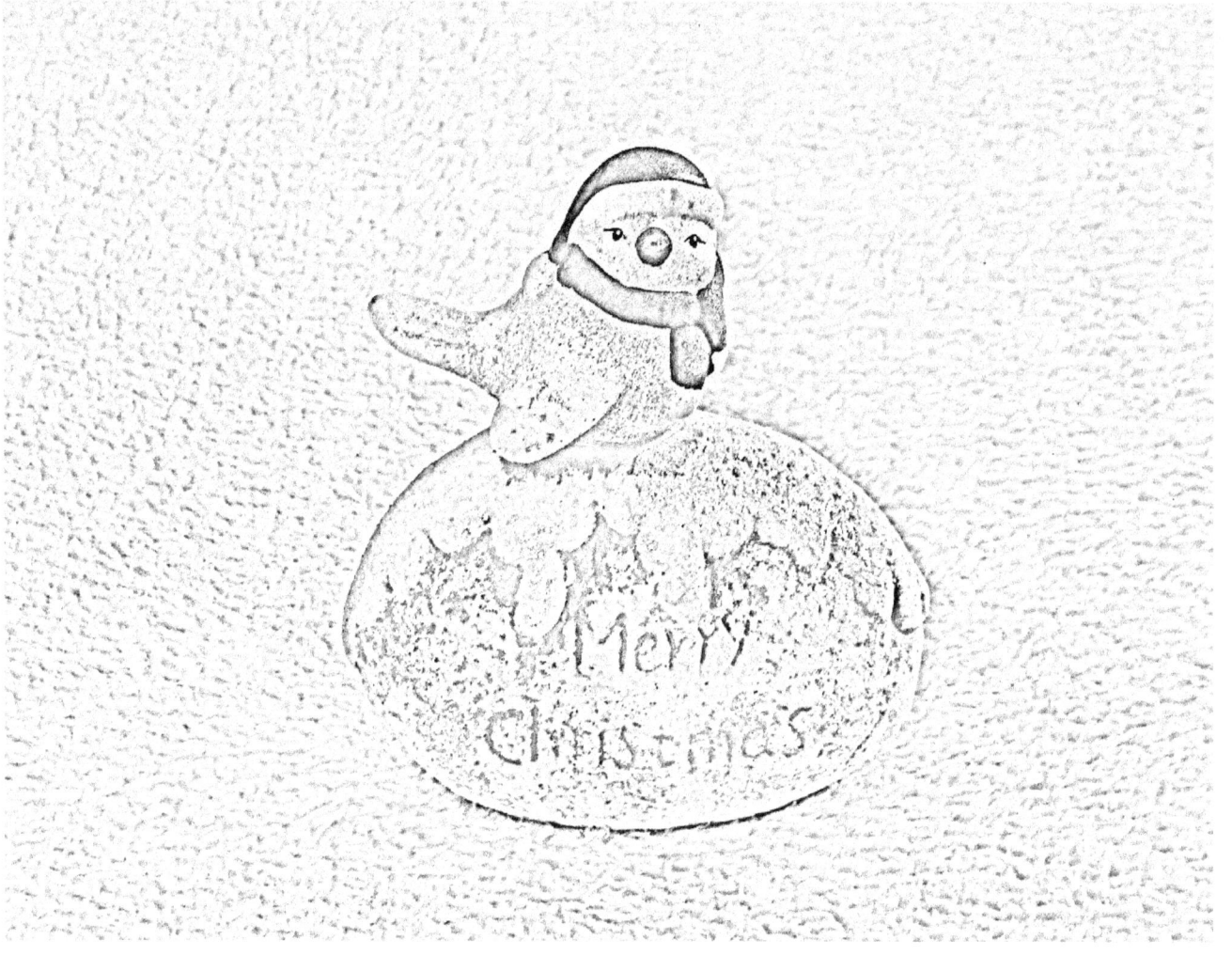

"Santa told me to watch you to see if you're naughty or nice."

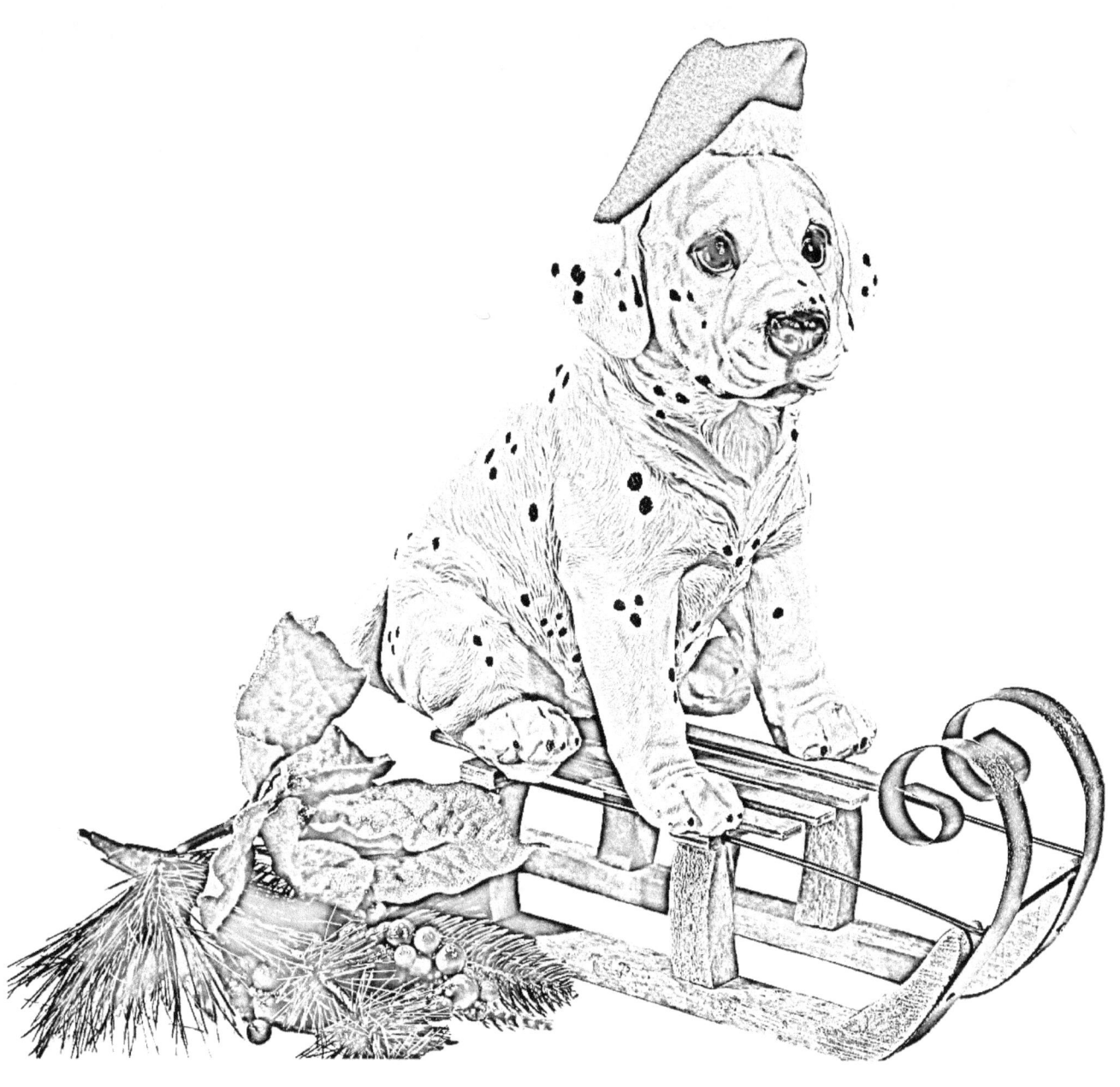

"I'm ready to go sled riding."

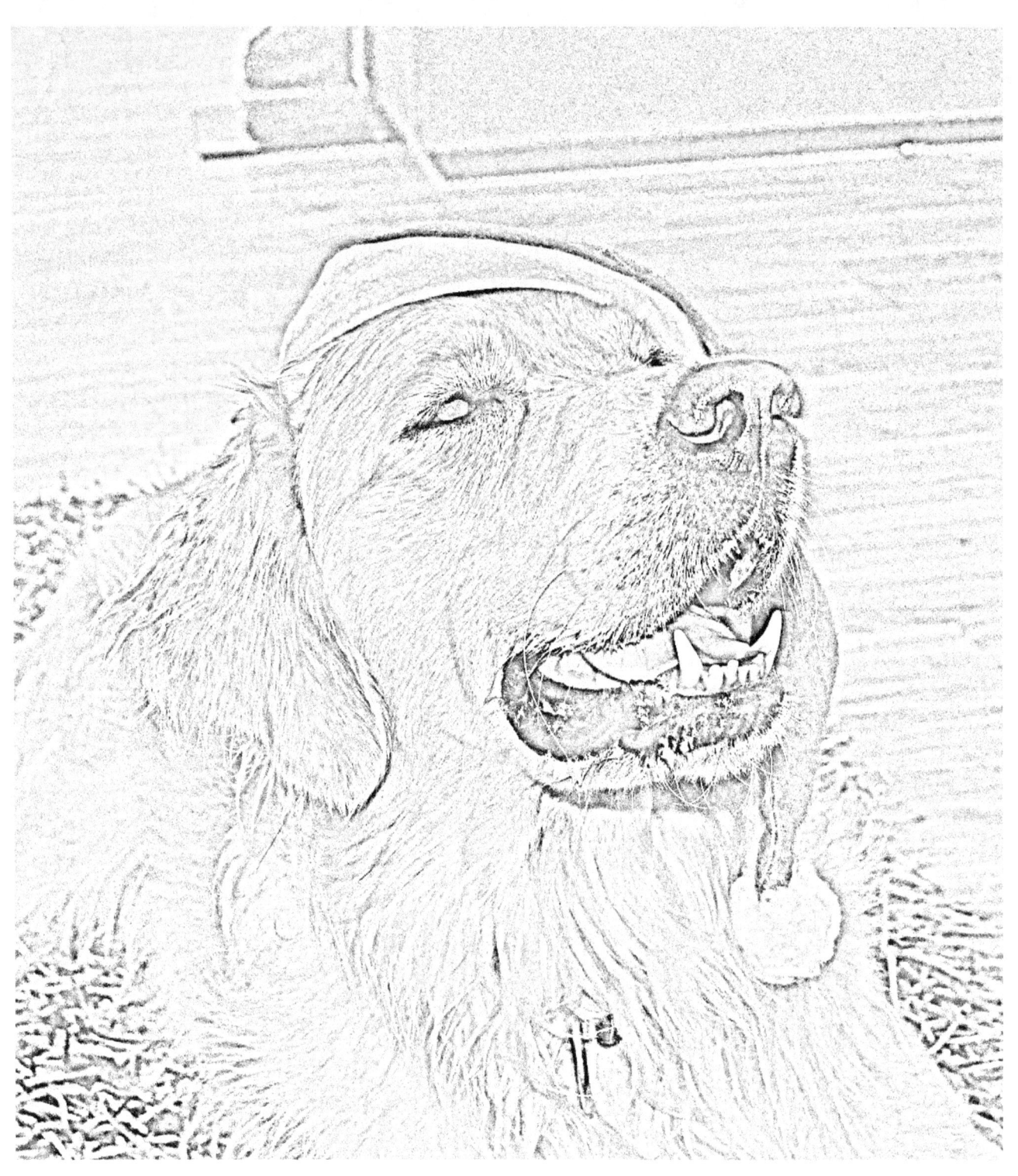

"Merry Christmas~"

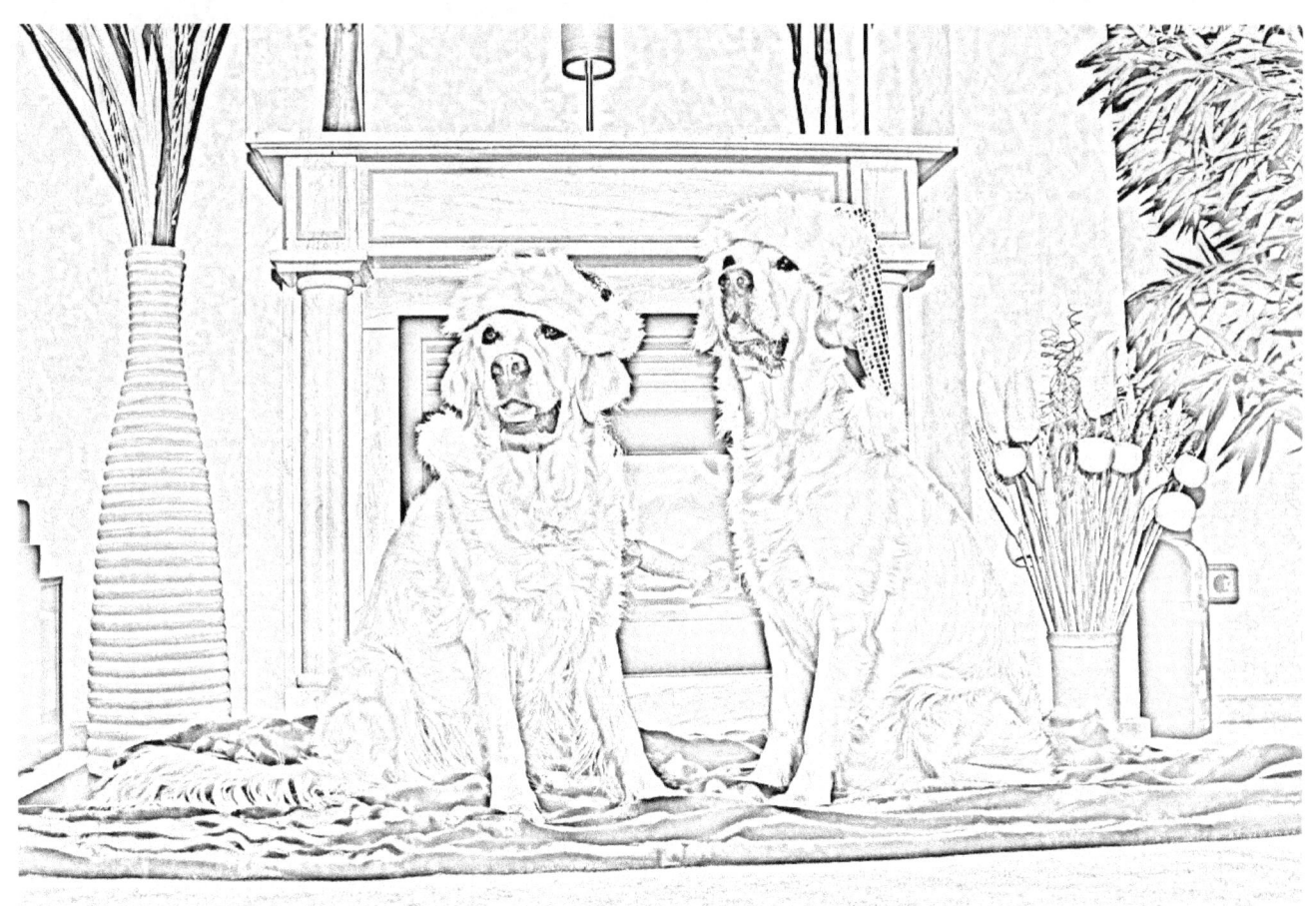

"We're guarding the fireplace for Santa."

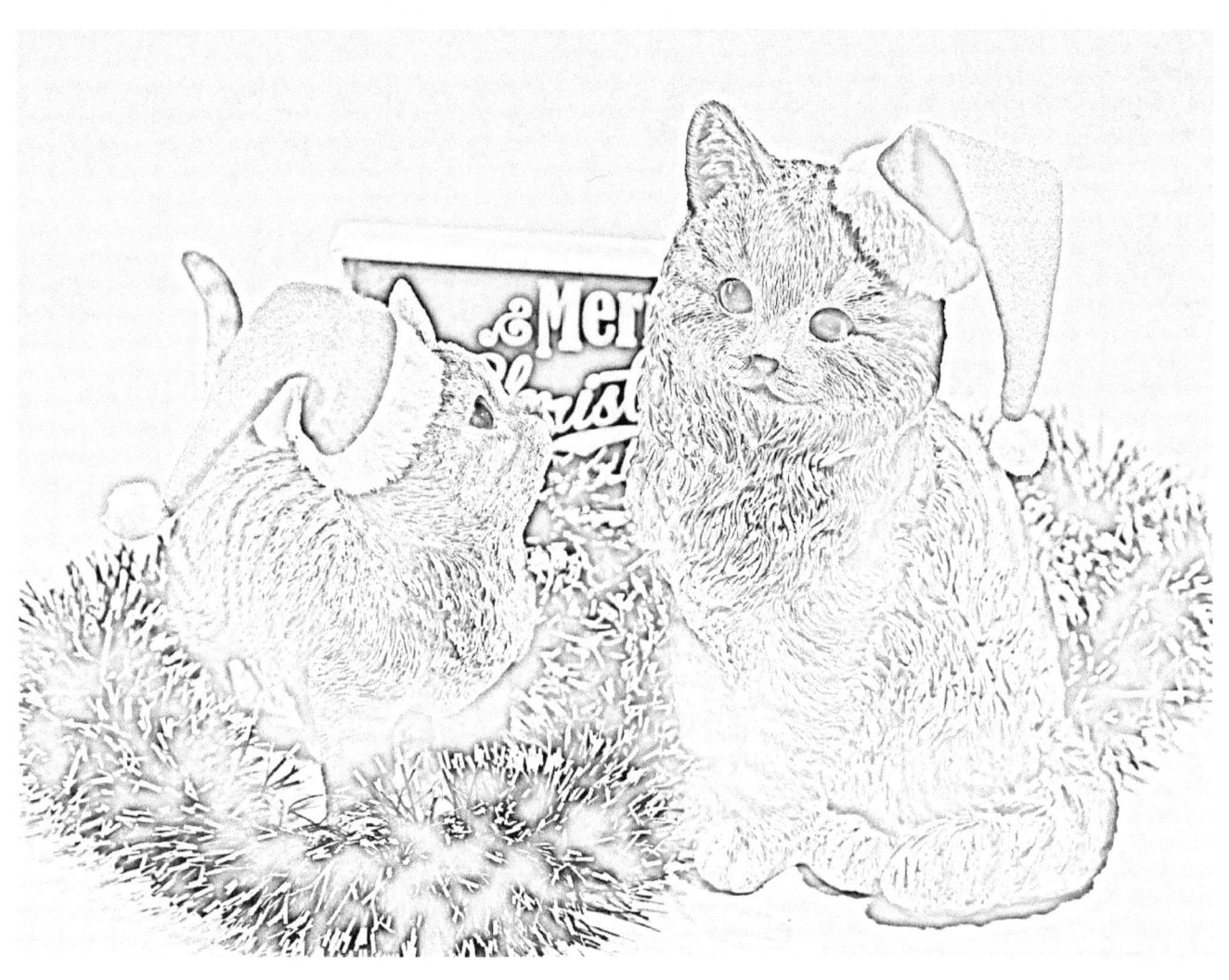

"I heard Santa's coming to town~"

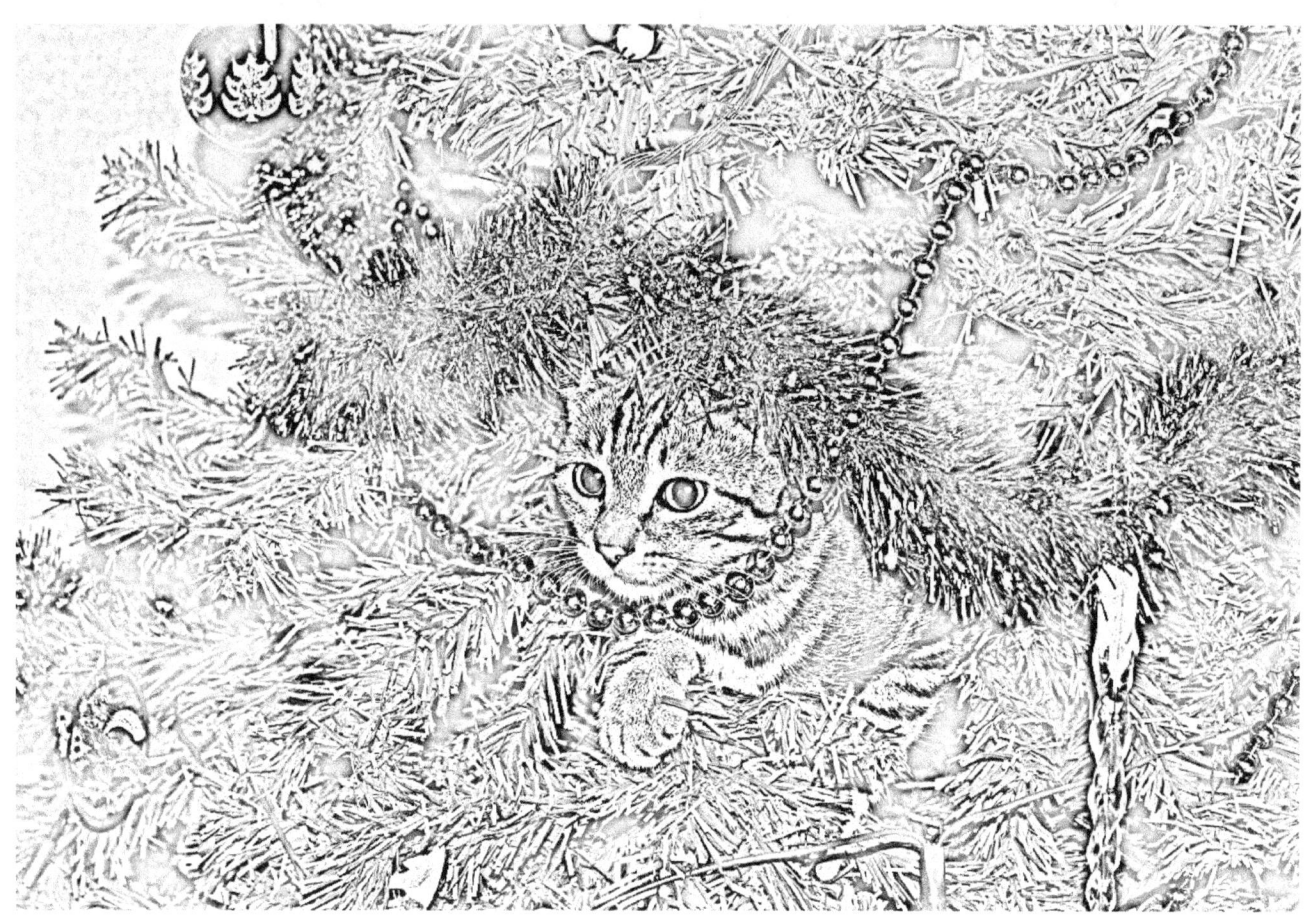

"I'm the cutest ornament on the tree~"

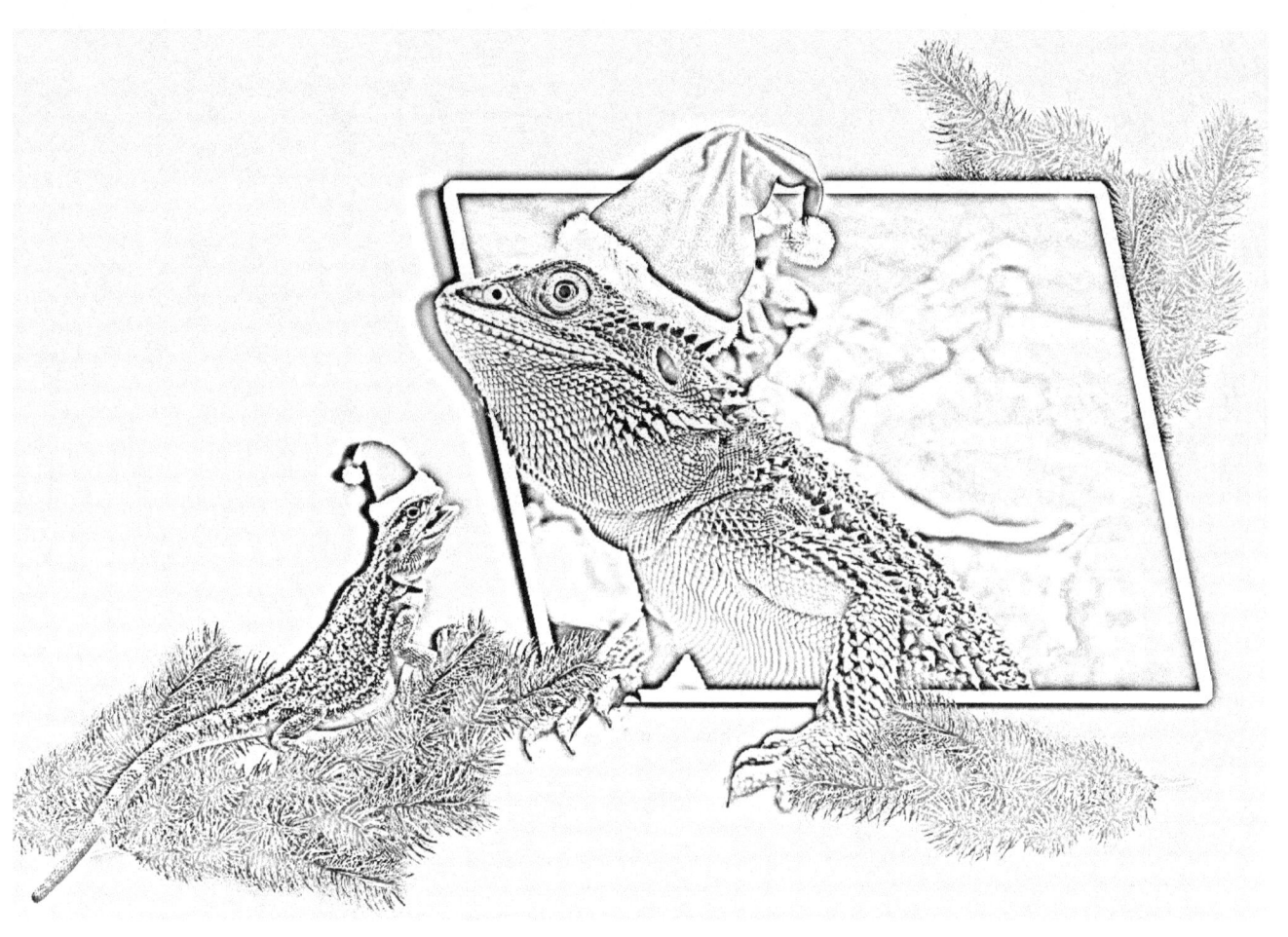

"I'm ready to be a Christmas card."

Merry Christmas

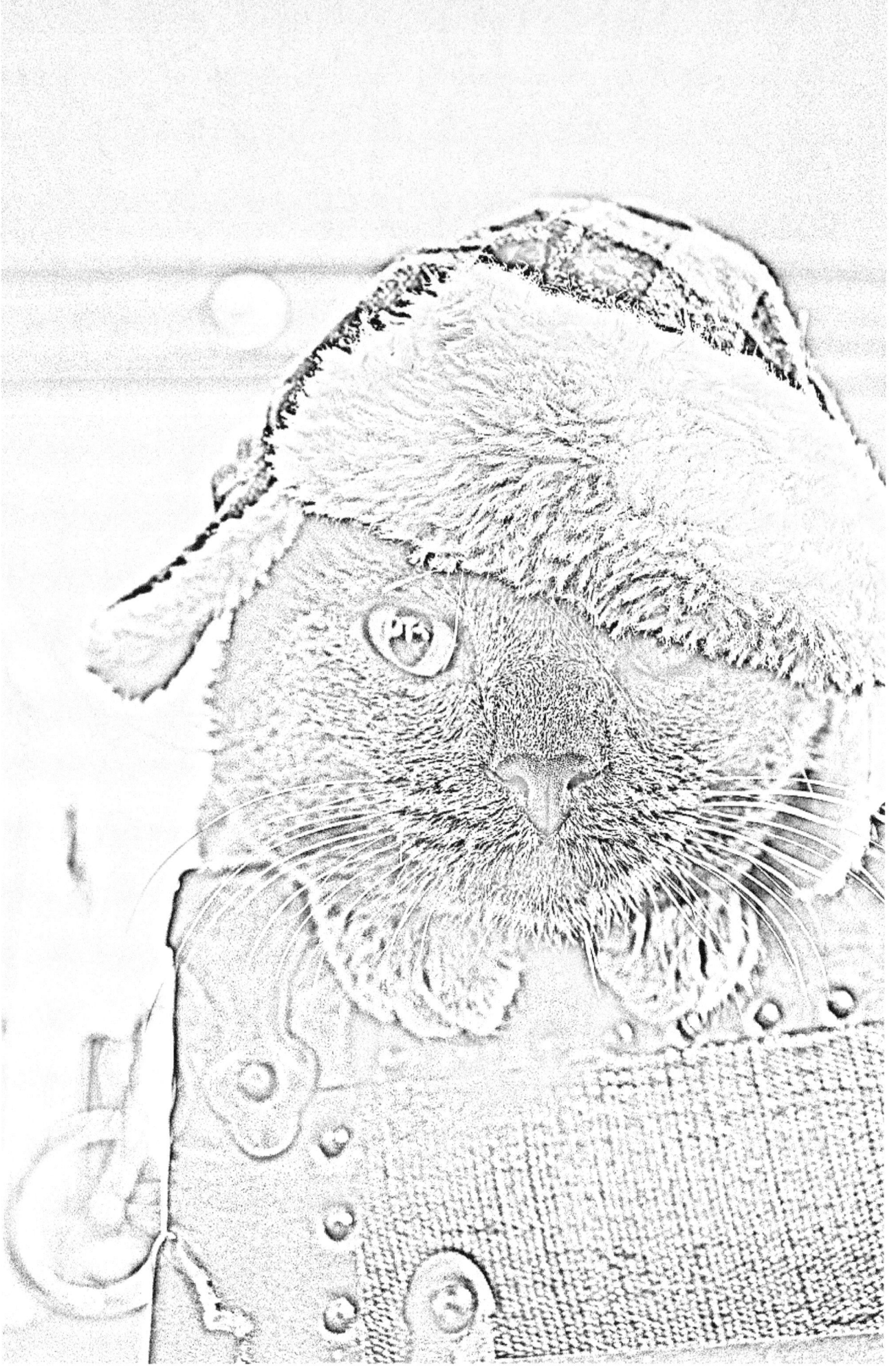

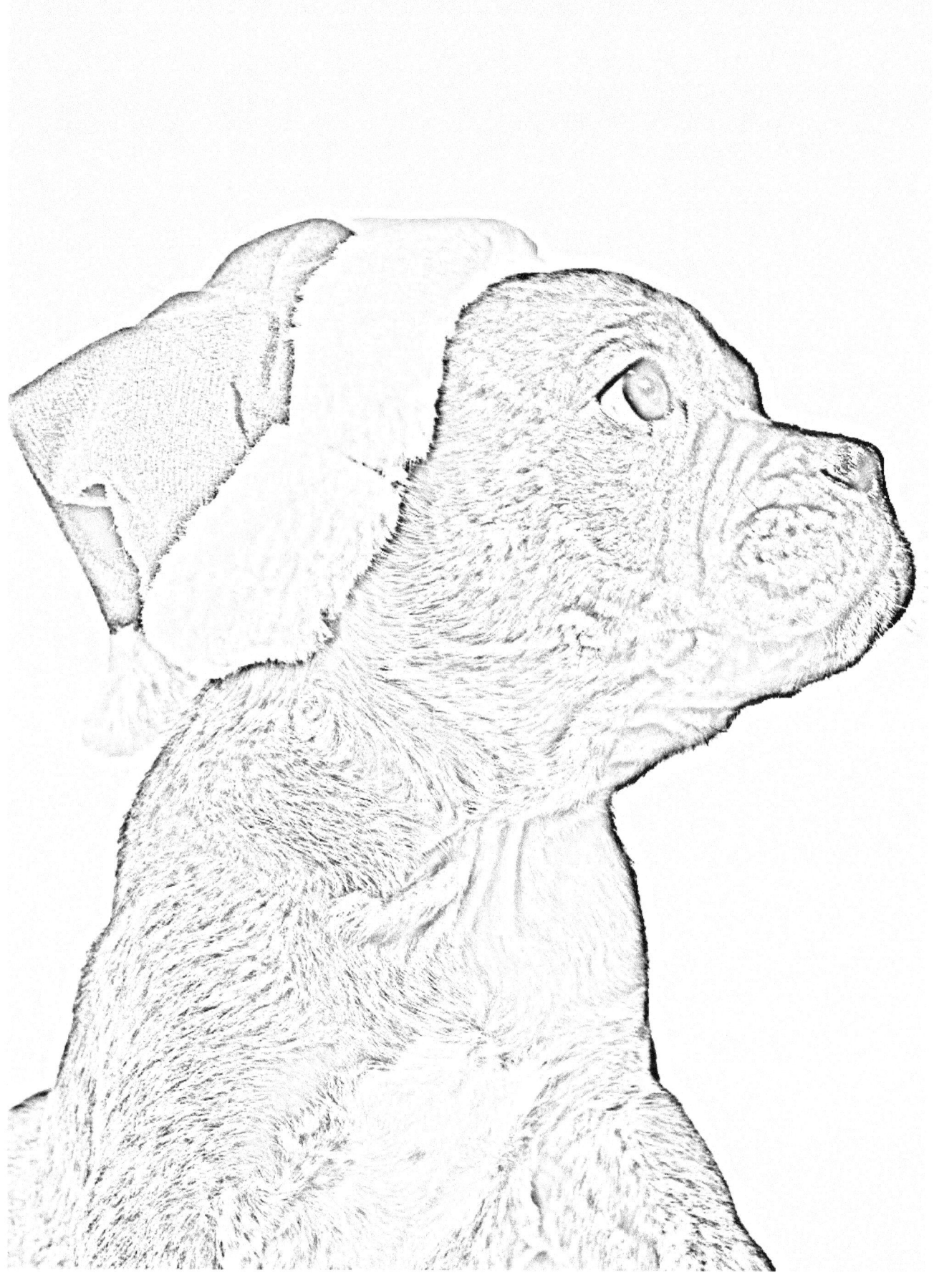

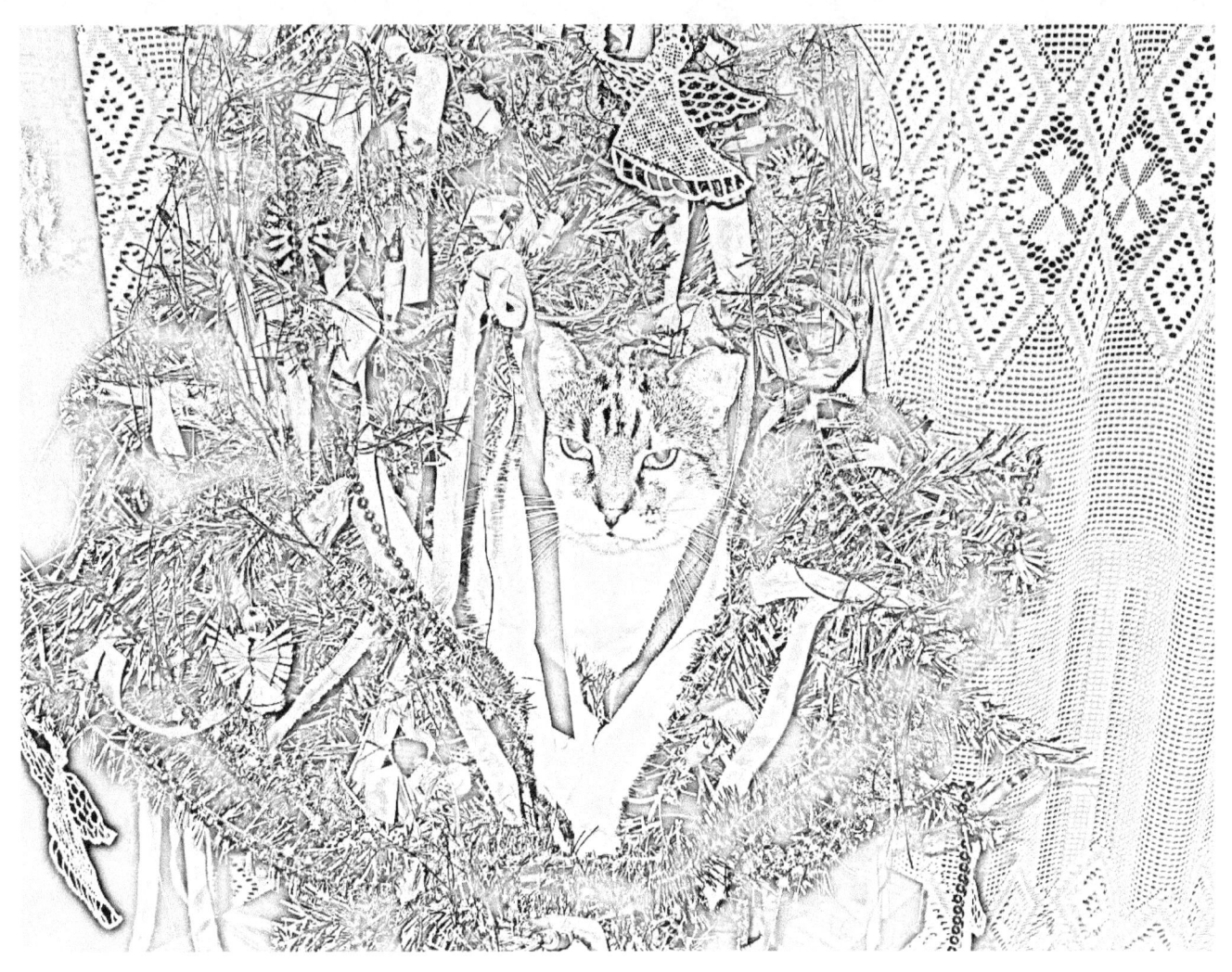

"I've been ripped off. This is a Charlie Brown Christmas tree."

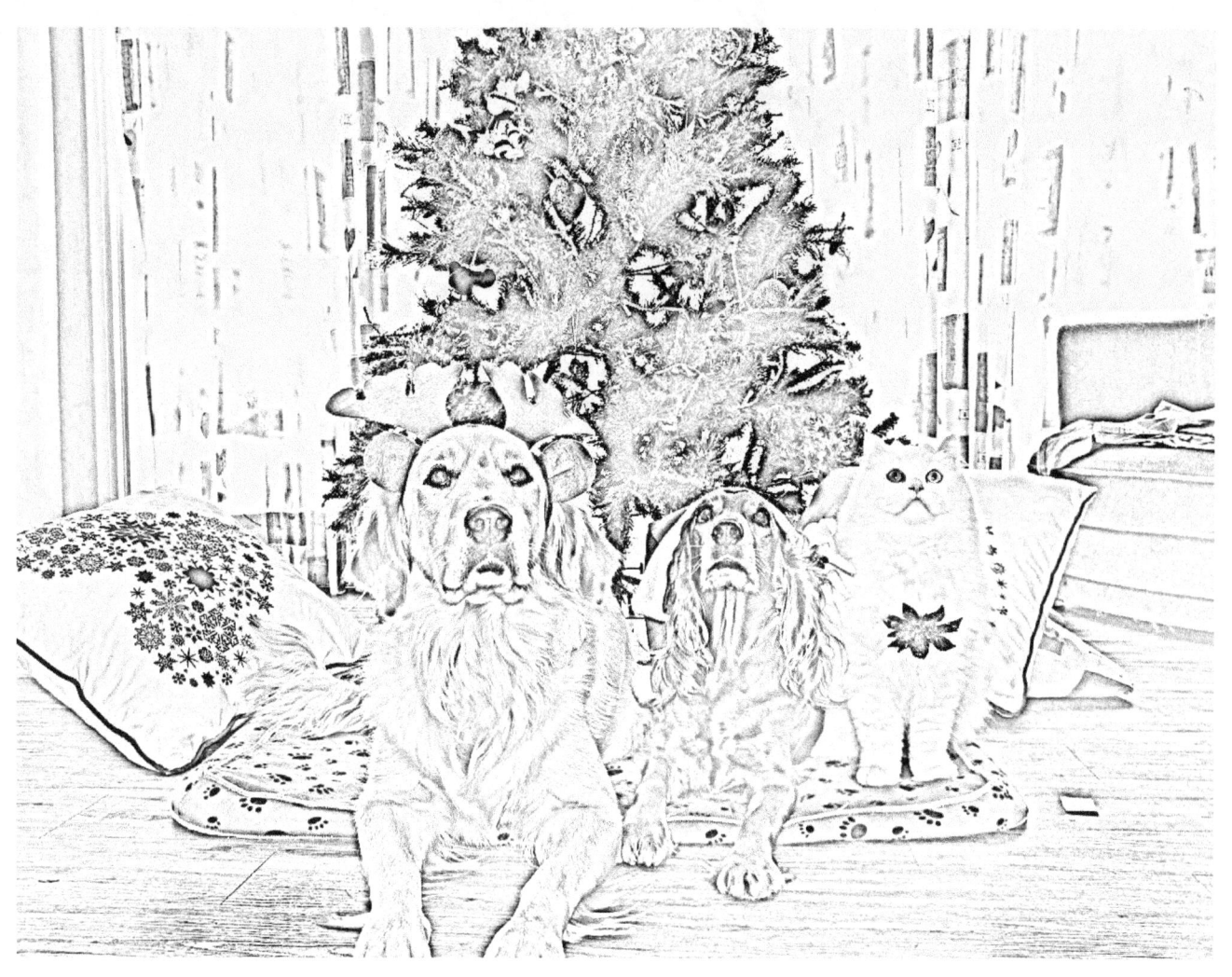

"Where's our presents?"

"Working for Santa is for the dogs."

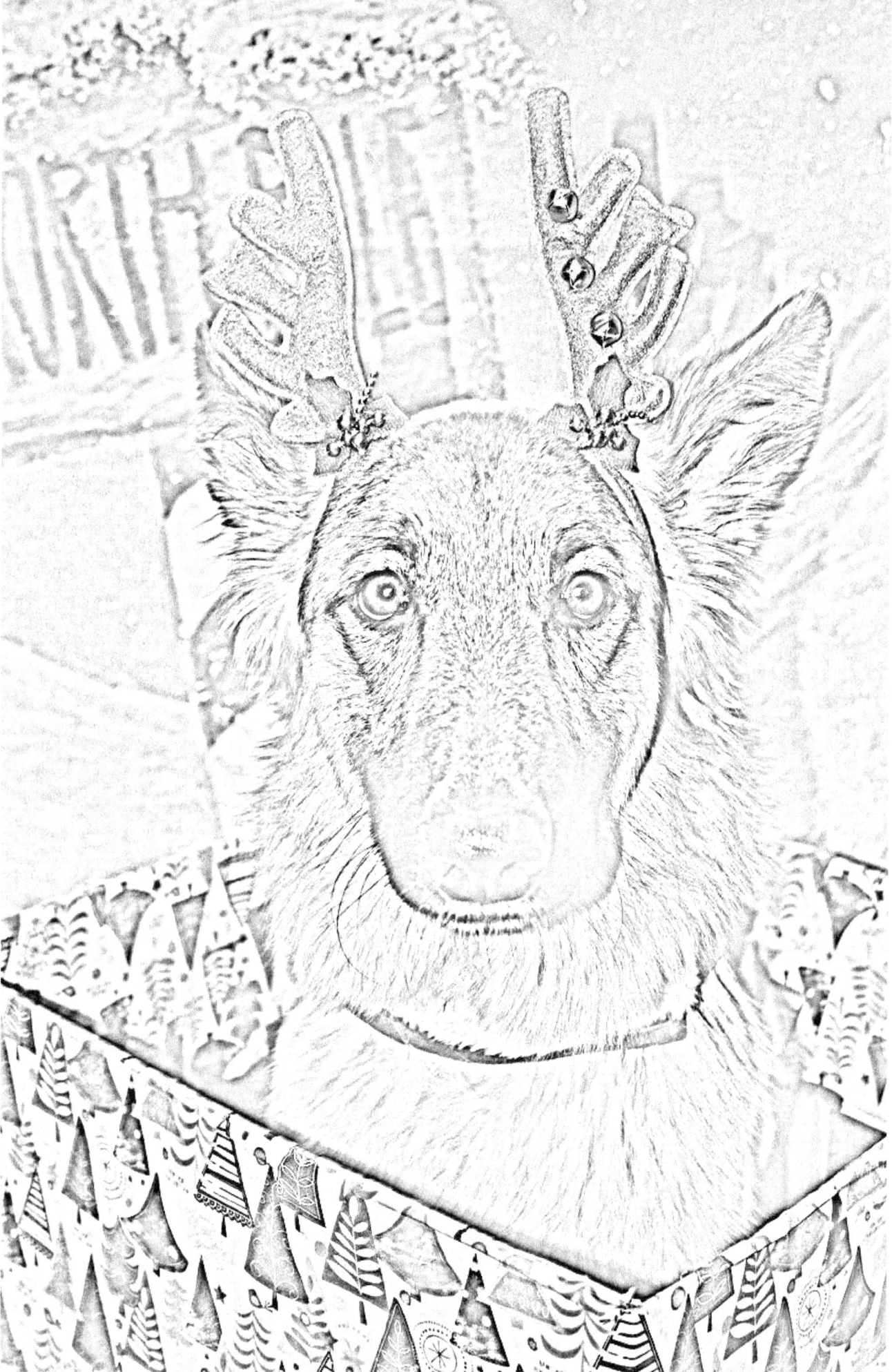

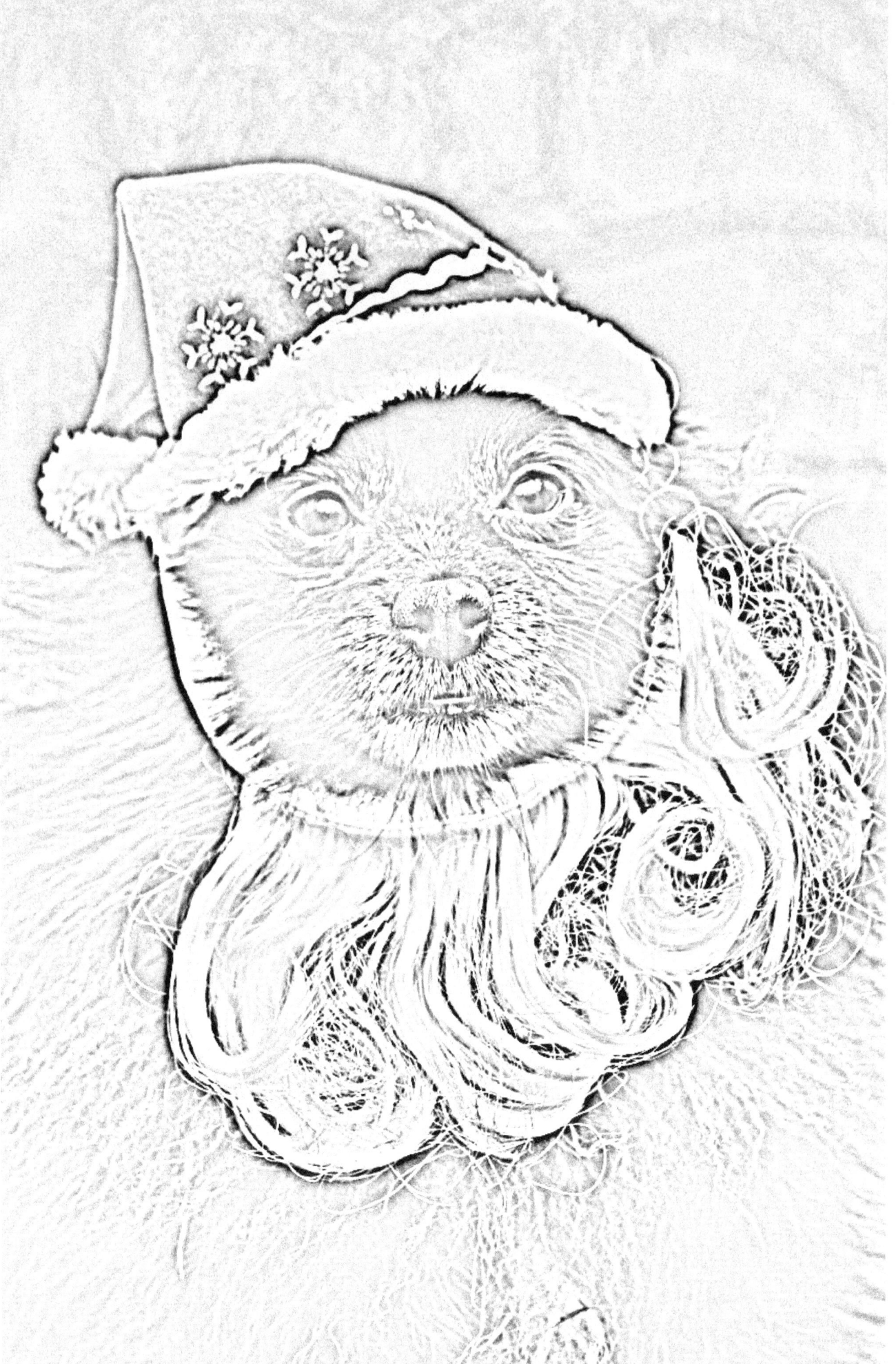

"We're here to join the reindeer games."

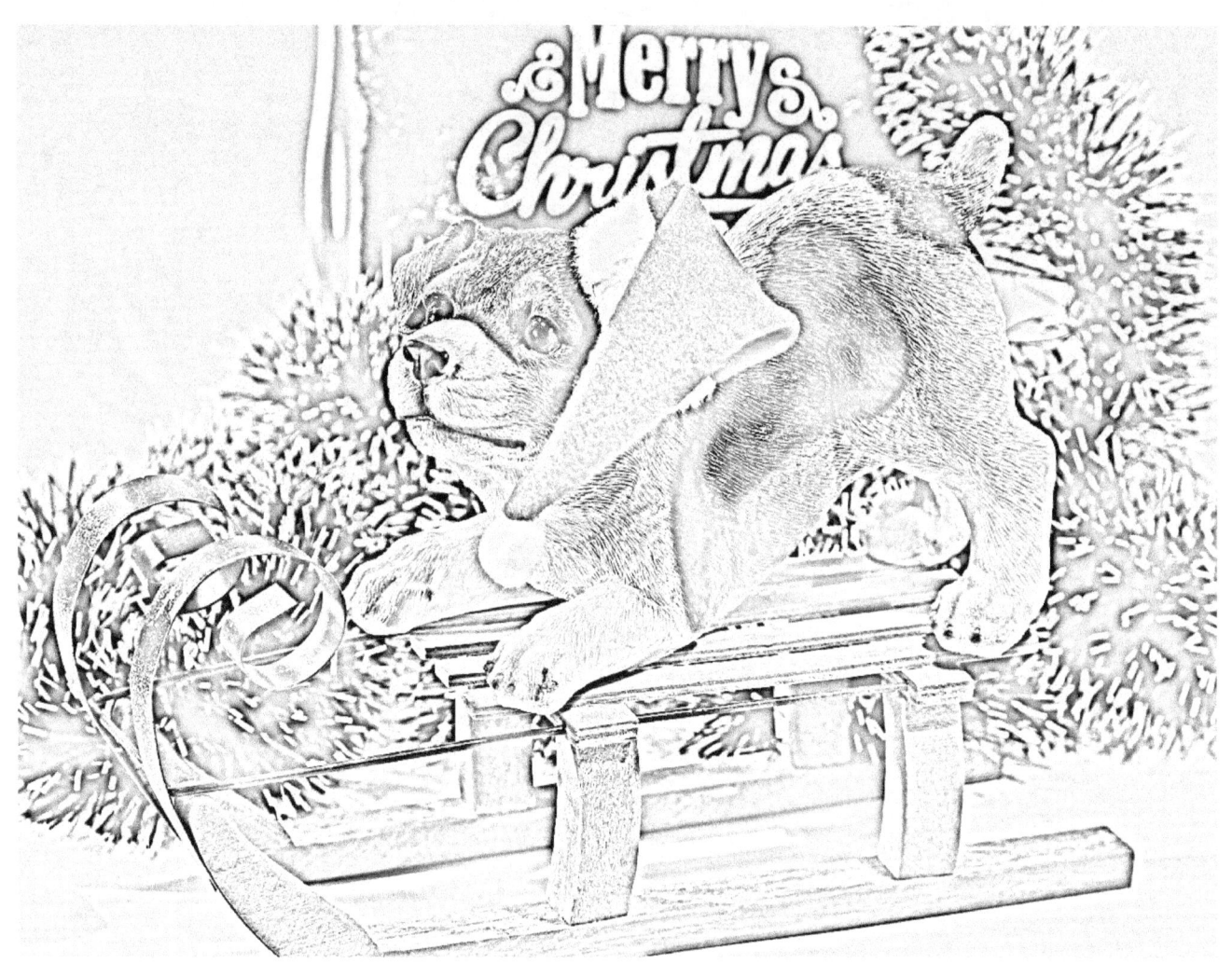

"I've got my sleigh, Where's the One-Horse?"

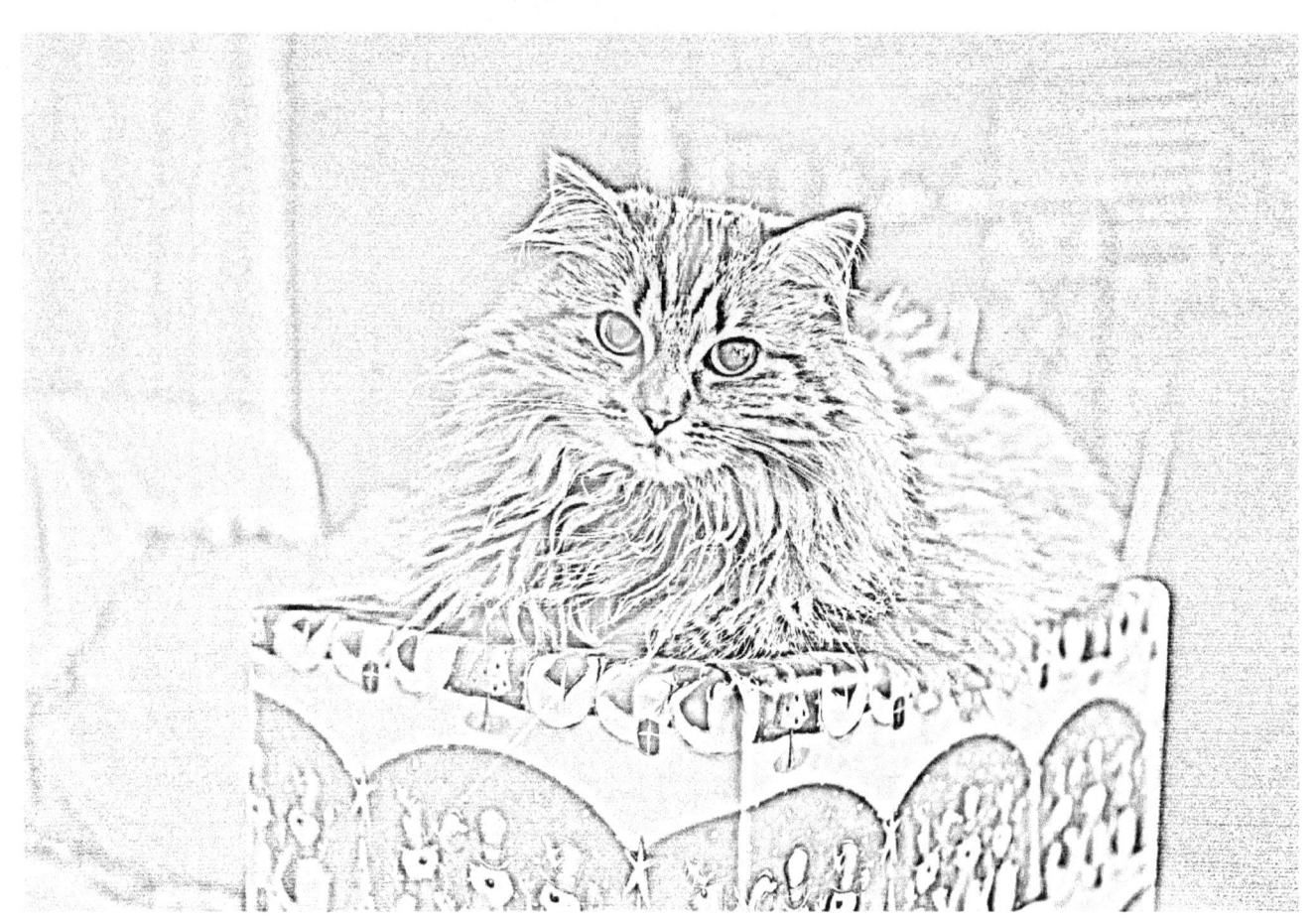

"I'm the best present under the tree."

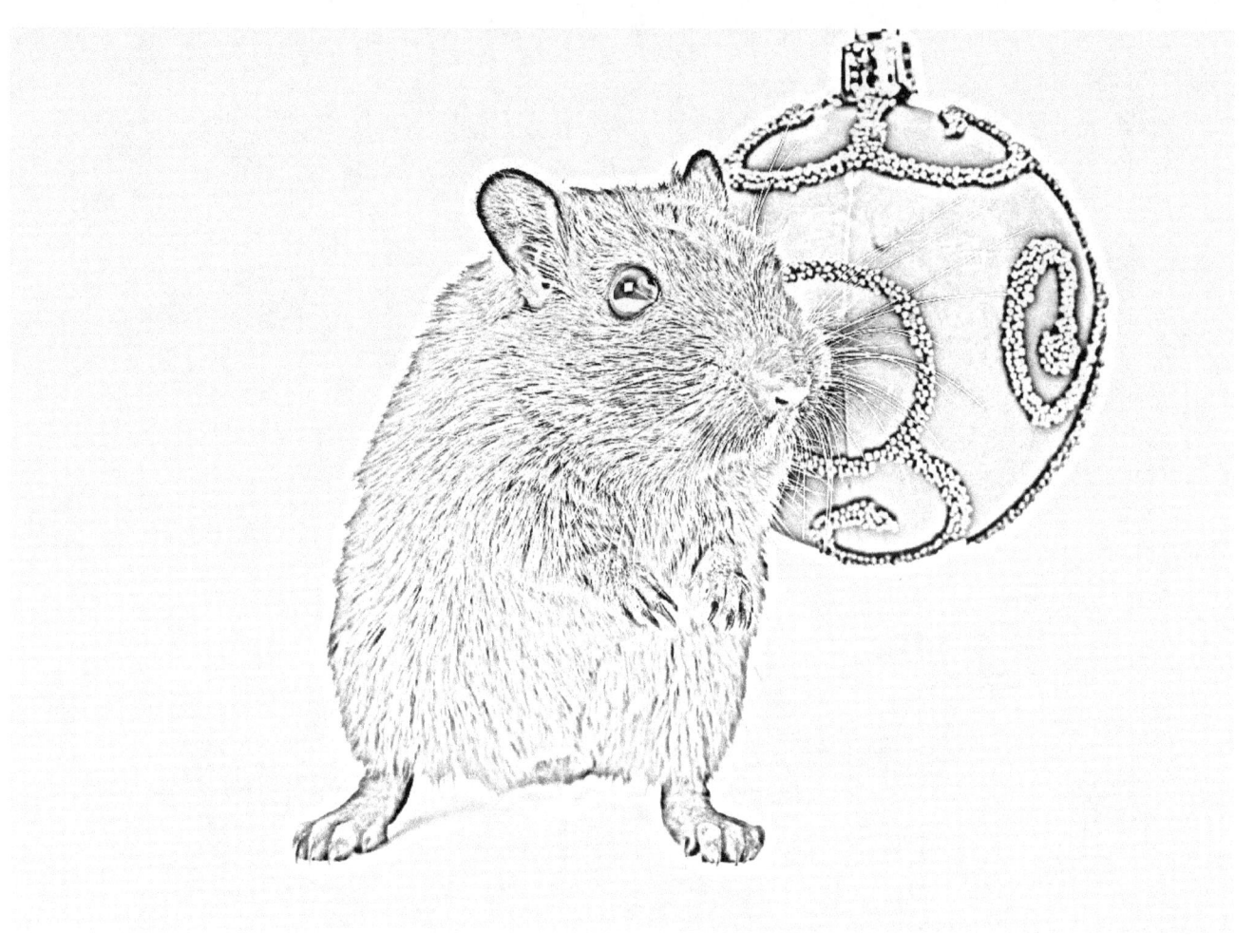

"And all through the house, Not a creature was stirring... EXCEPT for this mouse."

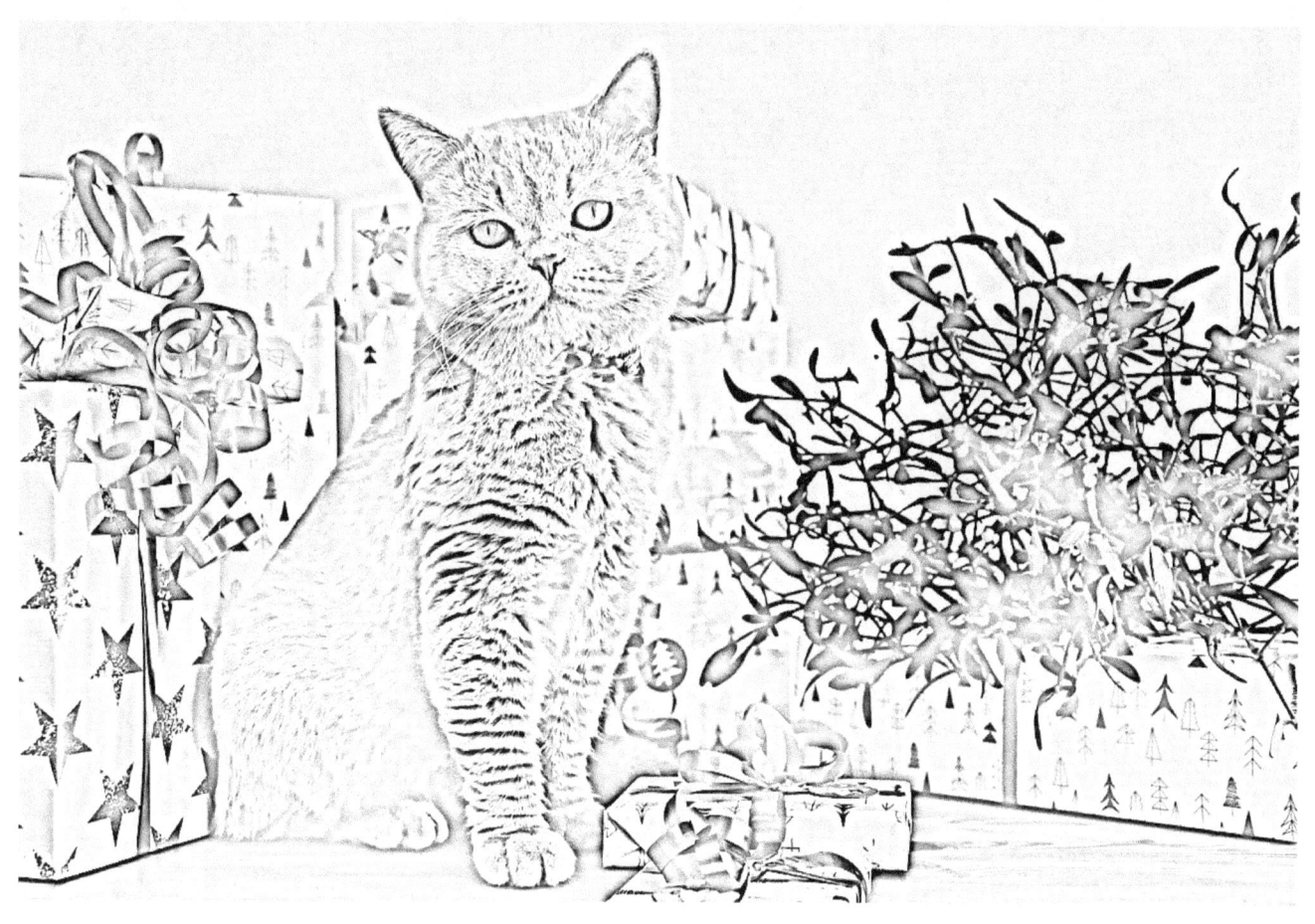

"You thought you got presents this year? Nope~
These are mine."

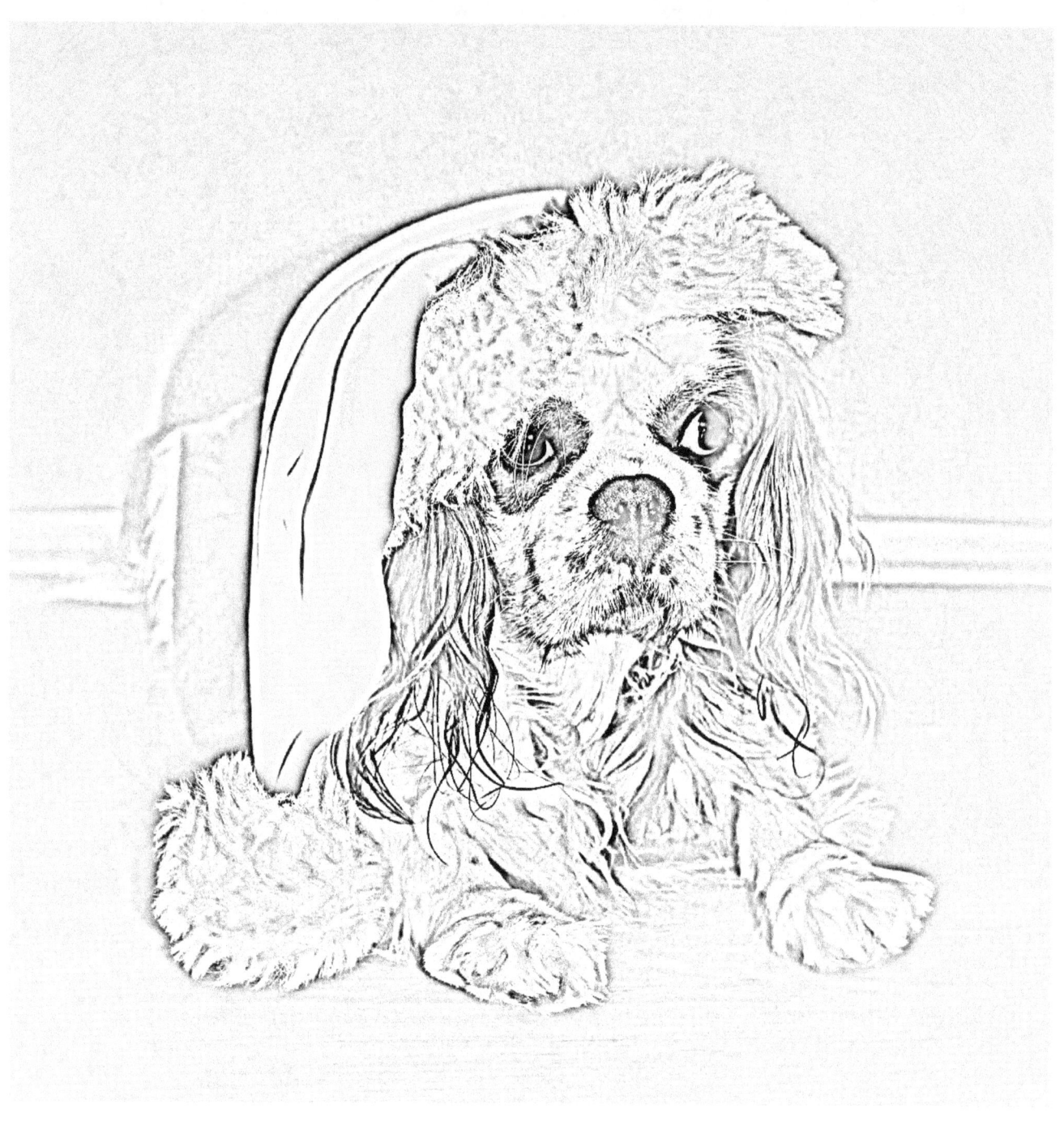

"Where's my treats? I've been good this year~"

Merry Christmas!
We hope you enjoyed our book.

Watch for more coloring books by ARN Arts LLC.
http://arnarts.wixsite.com/books